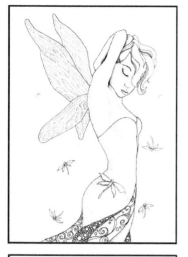
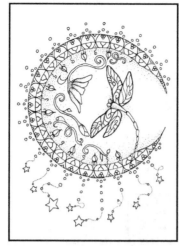

ADULT COLORING BOOK:
DRAGONFLY DREAMS
&
FAIRY WINGS

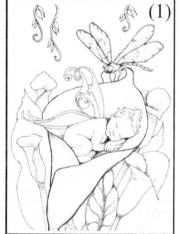
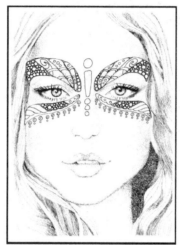

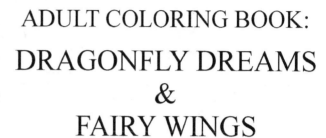

From the Pen-and-Ink Art of
CHERYL CASEY

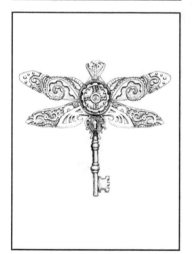
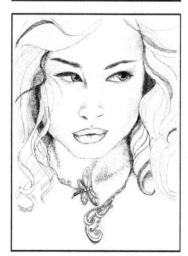

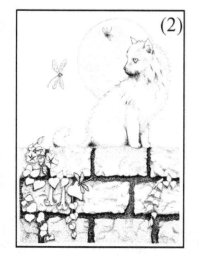
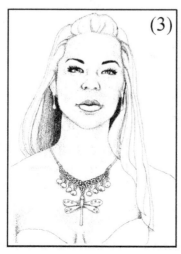

(1) Flower: Cala Lily
(2) Flower: Morning Glory
(3) My niece, Erica Smith, Navy veteran, Seahawks fan, amazing mom and wife

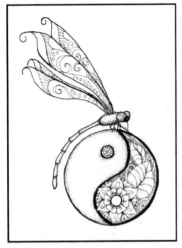
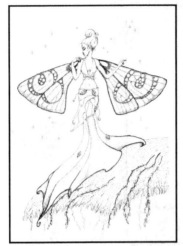

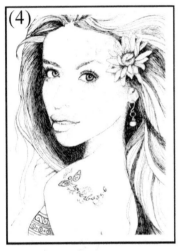
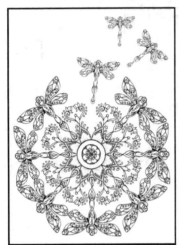

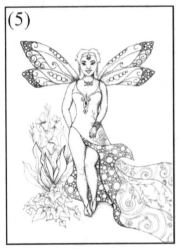
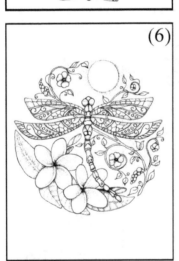

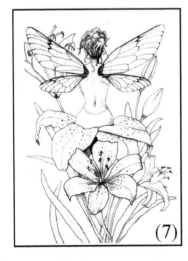
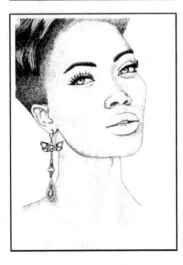

International Standard Book Number
ISBN-13: 978-1537320014
ISBN-10: 1537320017

www.cherylcaseyart.com

(4) Flower: Daisy. Tattoo: Proverbs 3, 5-6
(5) Inspired by family friend Erica Patchin, gypsy princess, woman extraordinair. Flower: Cana.
(6) Flower: Plumeria
(7) Flower: Tiger Lily.

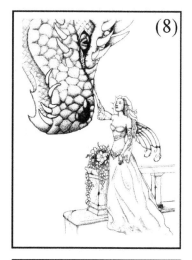 (8)

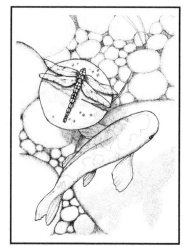

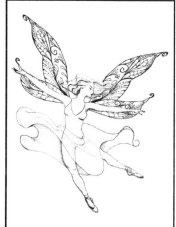

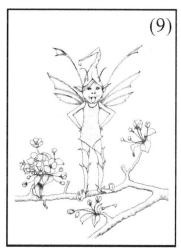 (9)

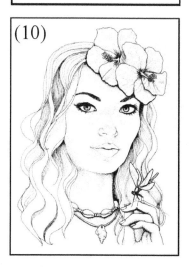 (10)

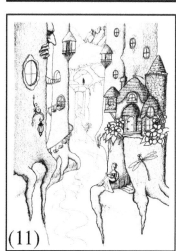 (11)

Coloring friends, please feel free to copy the art pages onto your favorite art paper, cardstock, etc., whatever best suits your preferred medium. For your personal use.

I would love, love, LOVE to see your finished coloring art from this book. Stop by my facebook page and share a photo of your work: facebook.com/ cherylcaseyart.

You might also check out some of the facebook groups dedicated to Coloring Books for Adults. Some amazingly supportive people just like you and me, plus good tips on supplies and techniques, and lots of photos to browse and be inspired by. A great place to show your work.

Now here's an odd request - if you happen to get a tattoo of one of my drawings (you do have my express permission to do that), that would be cool and I'd love to see it. I might even start a tats page on my website. Just share a photo of your tat to my facebook page.

Happy coloring!
-Cheryl

(8) Flower: Magnolia
(9) Flower: Crabapple blossom
(10) Flower: Hibiscus
(11) Flower: Forget-Me-Not

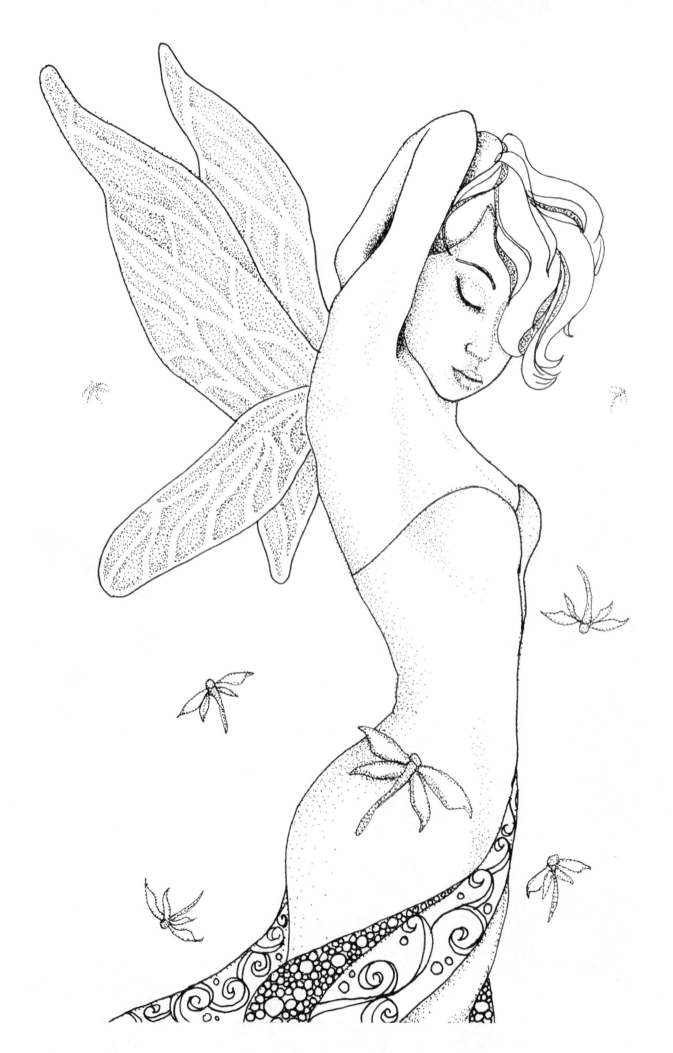

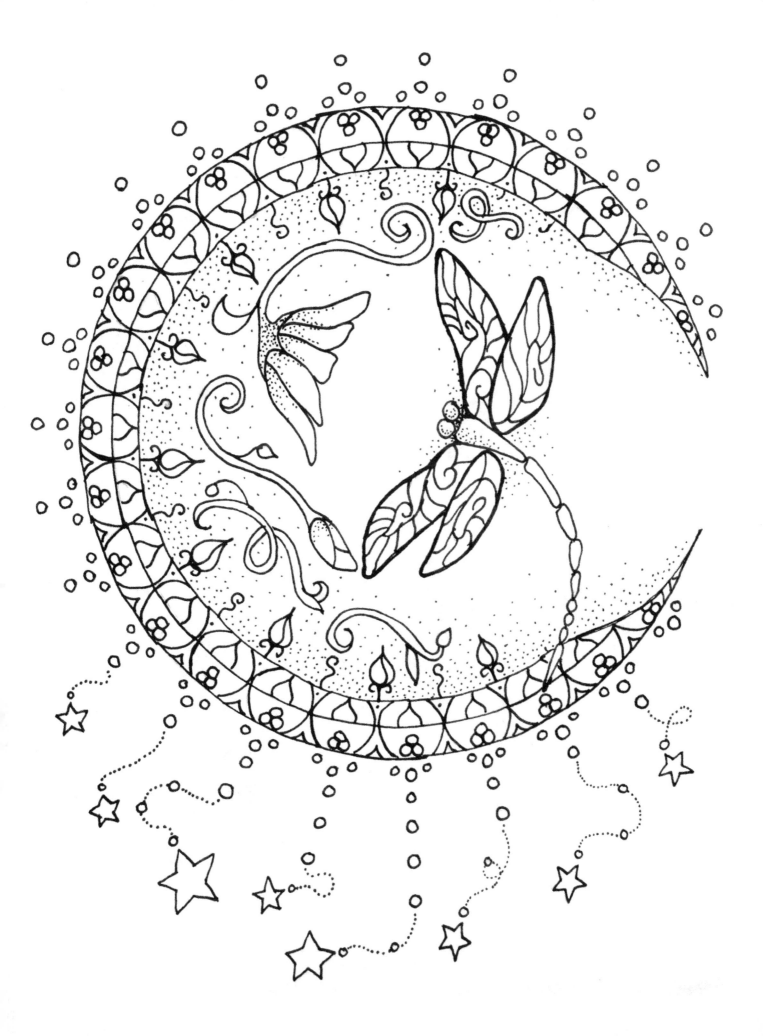

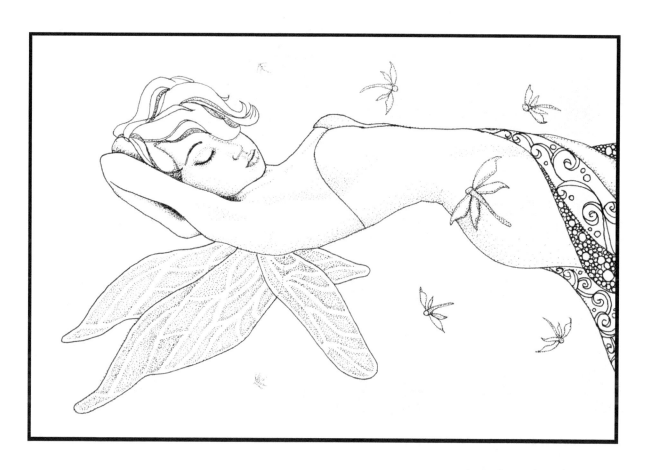

4x6 for photo frame

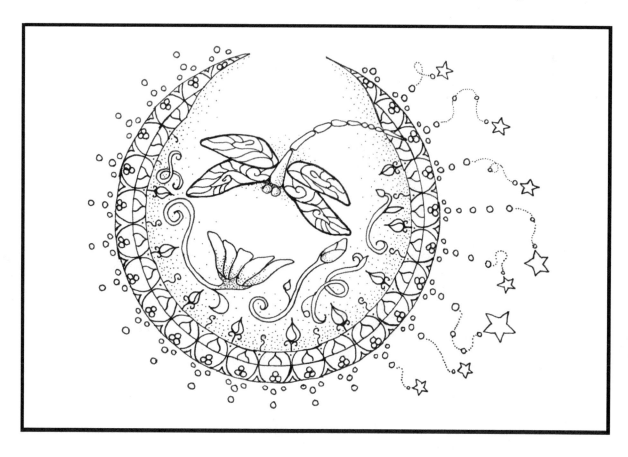

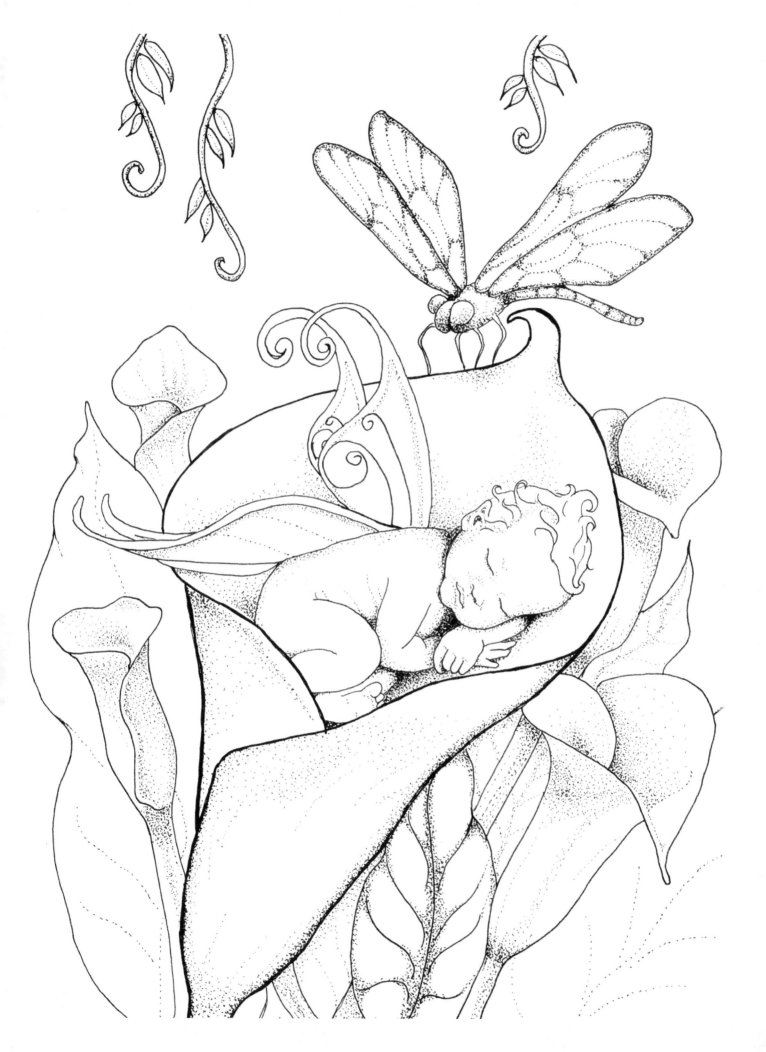

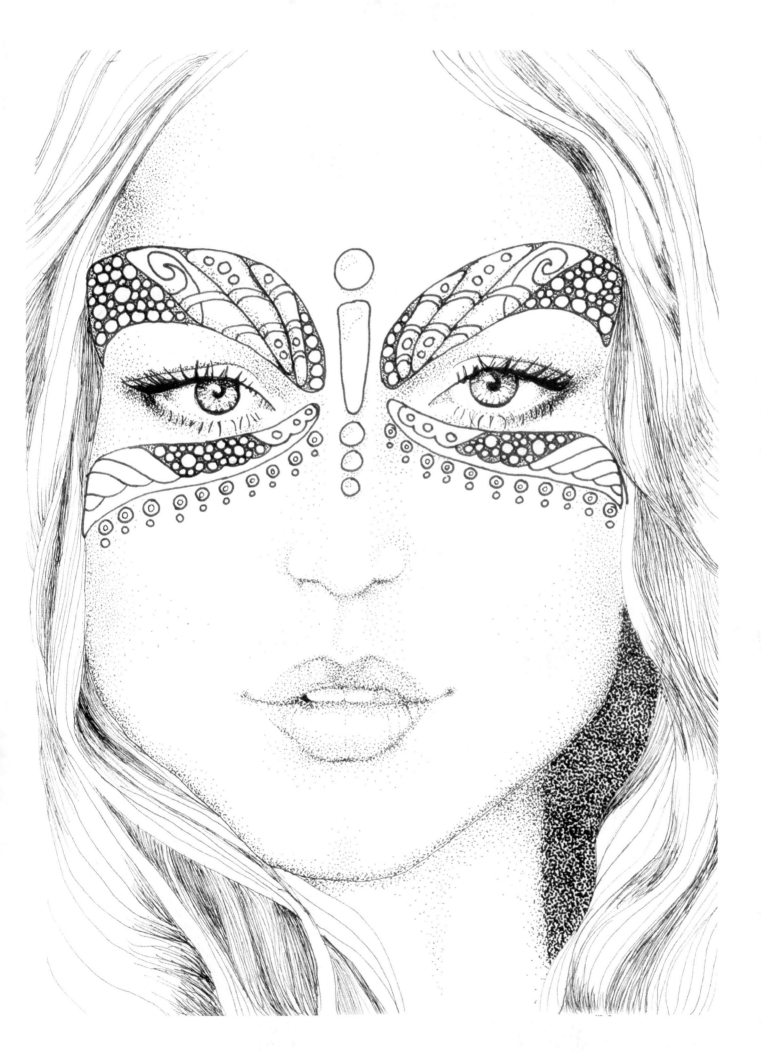

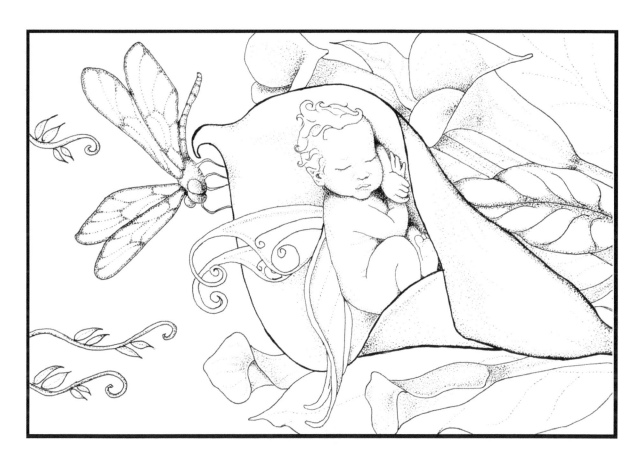

4x6 for photo frame or greeting card

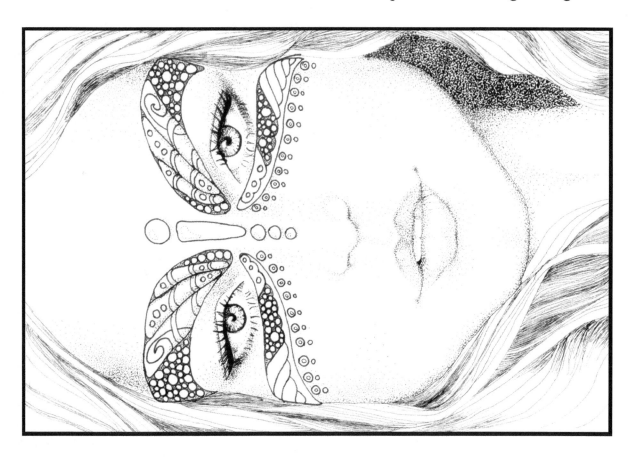

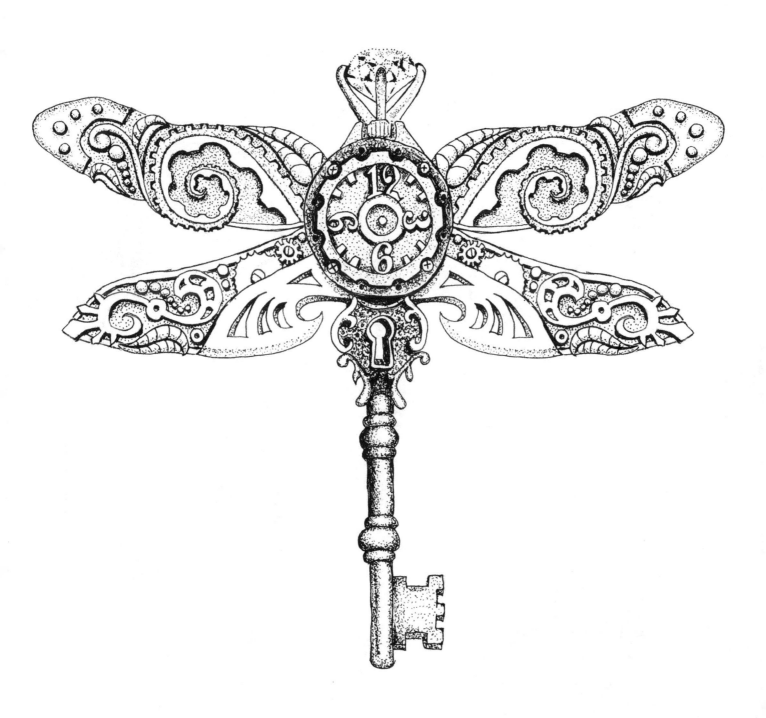

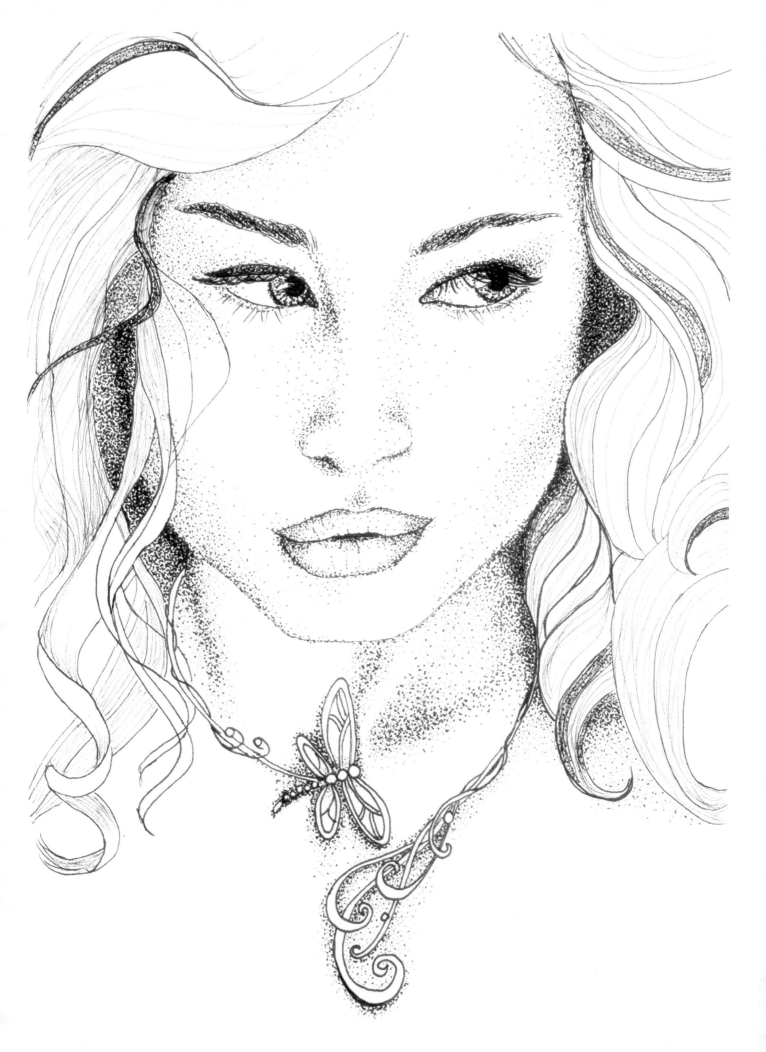

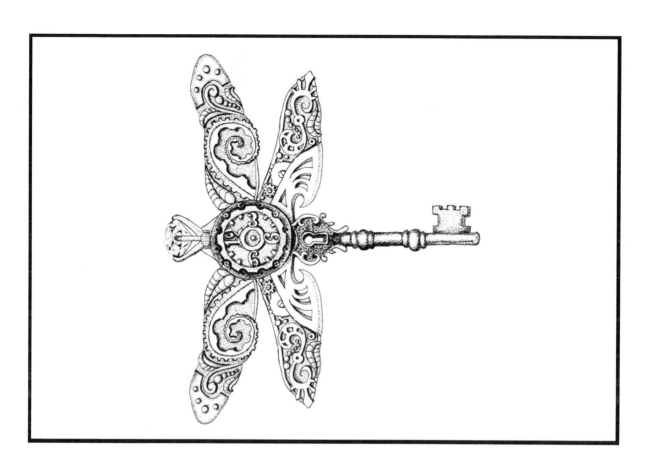

4x6 for photo frame or greeting card

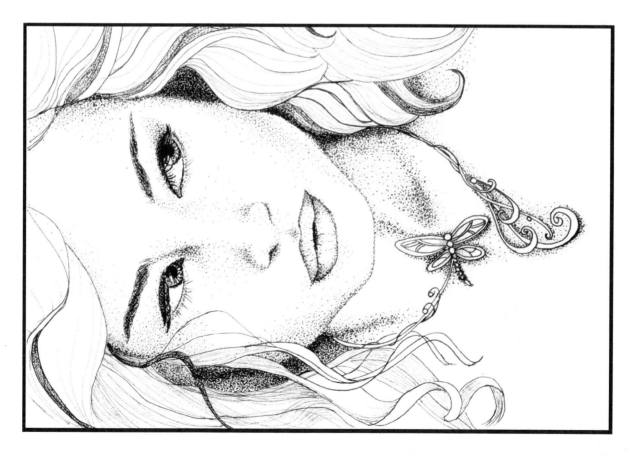

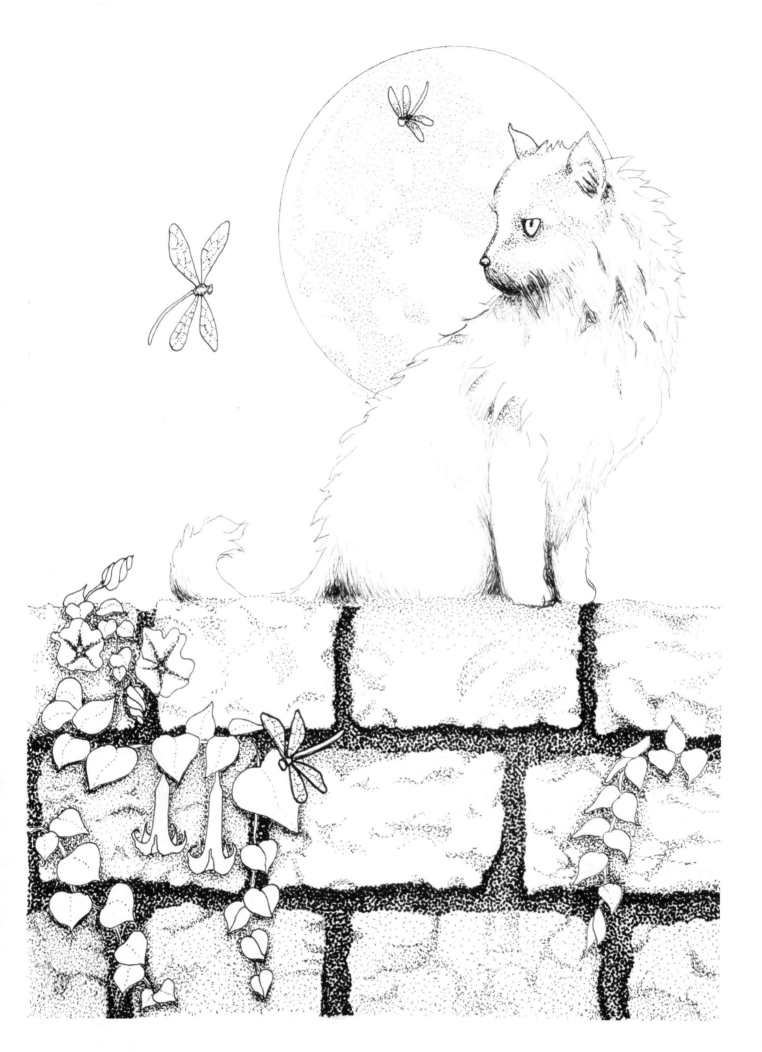

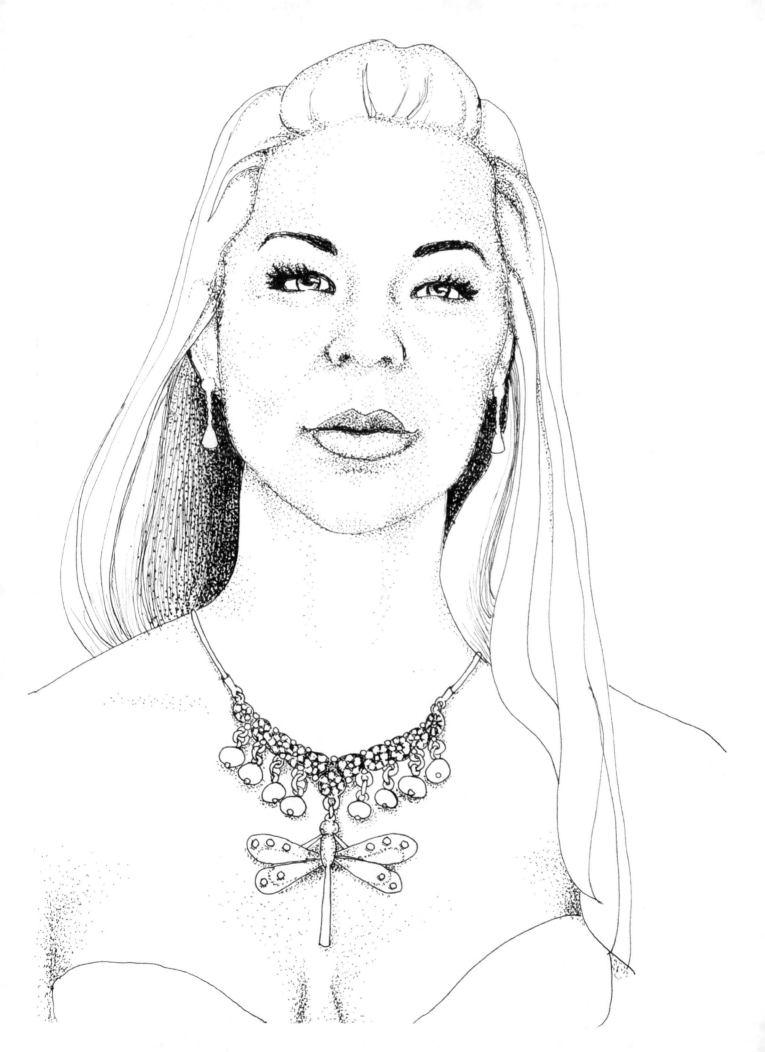

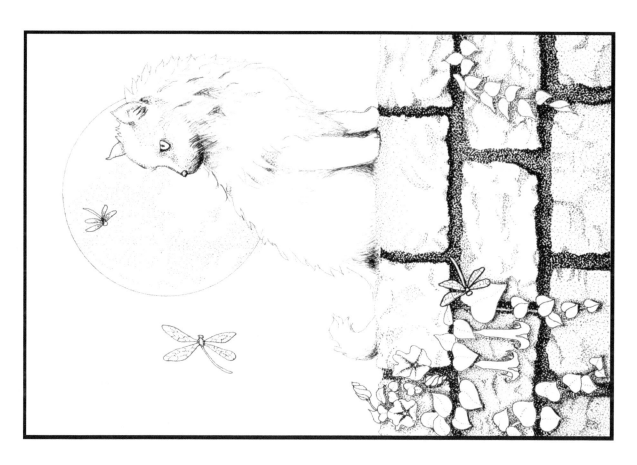

4x6 for photo frame or greeting card

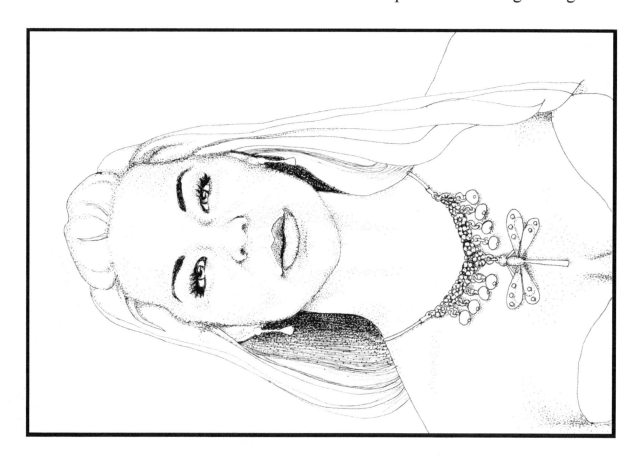

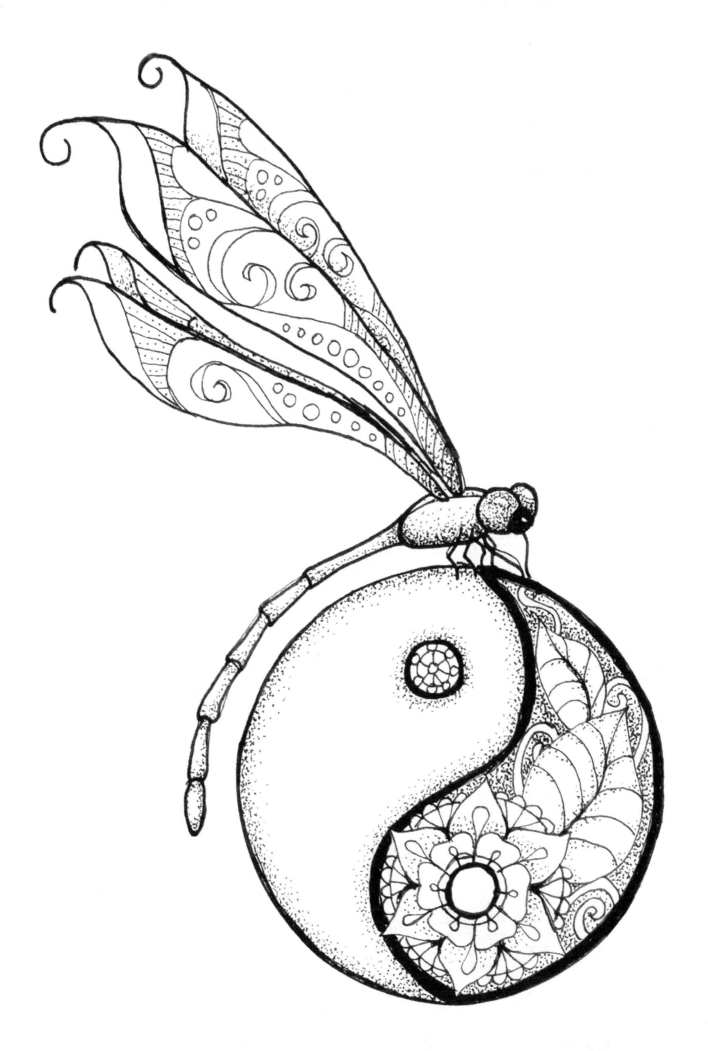

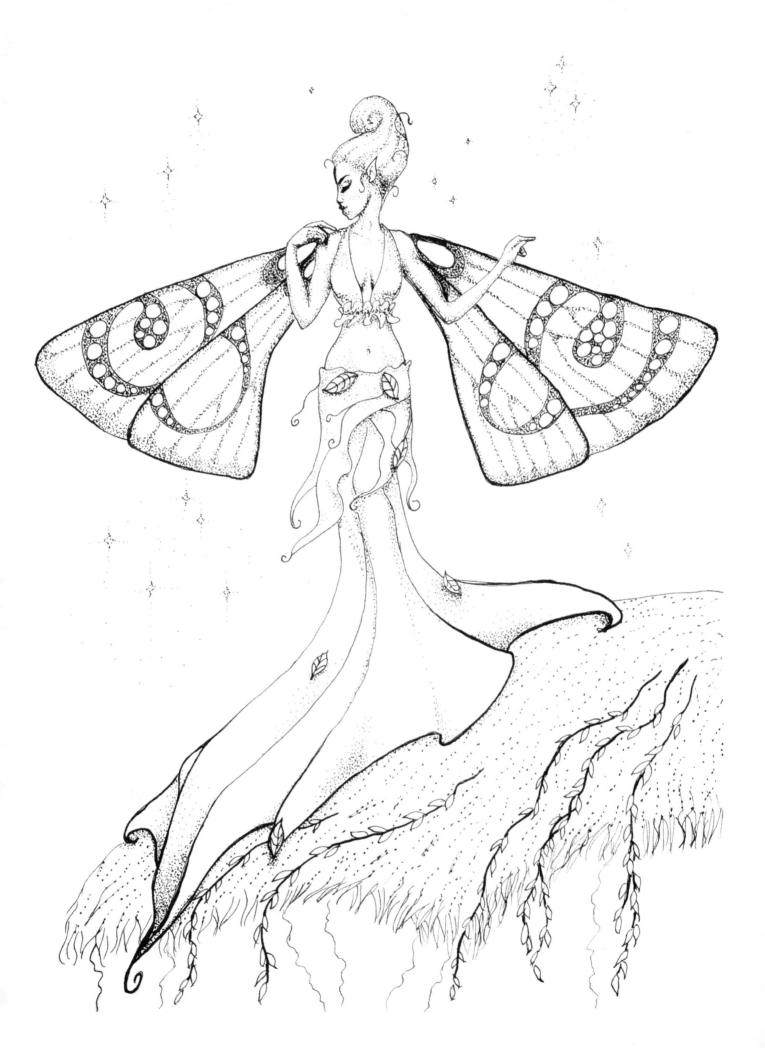

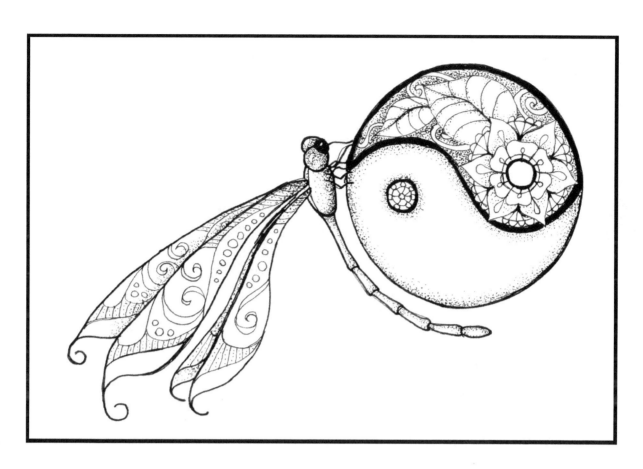

4x6 for photo frame or greeting card

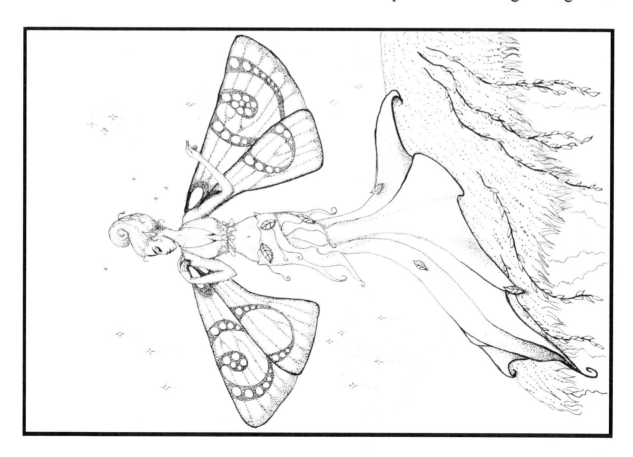

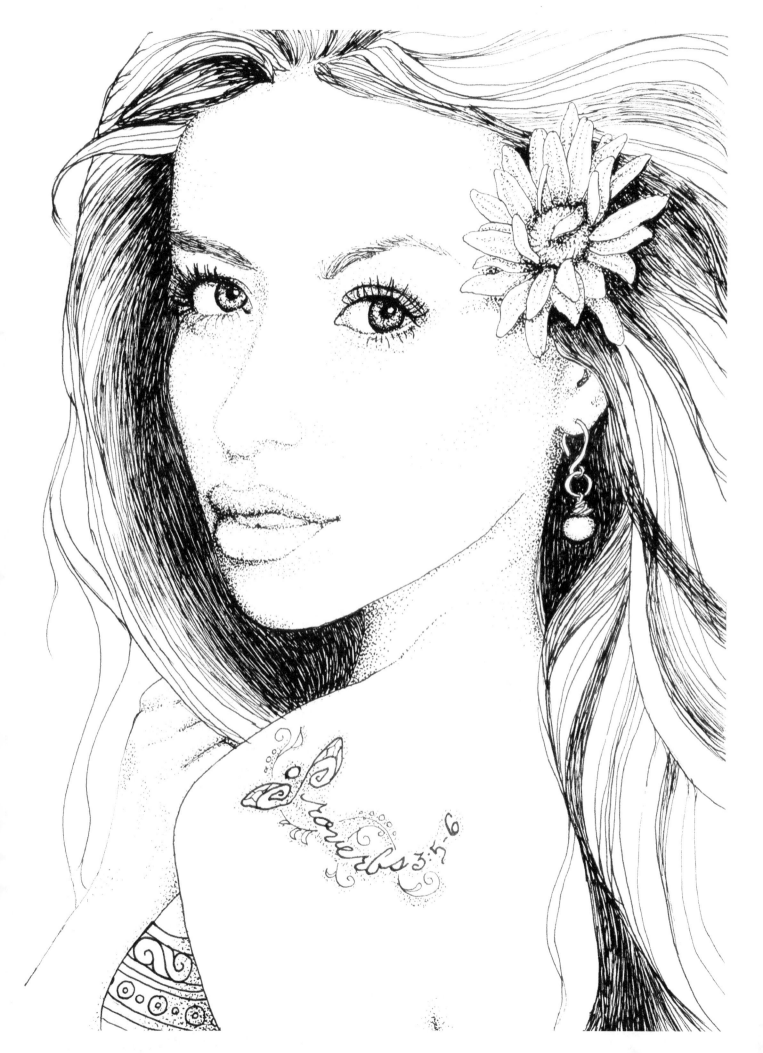

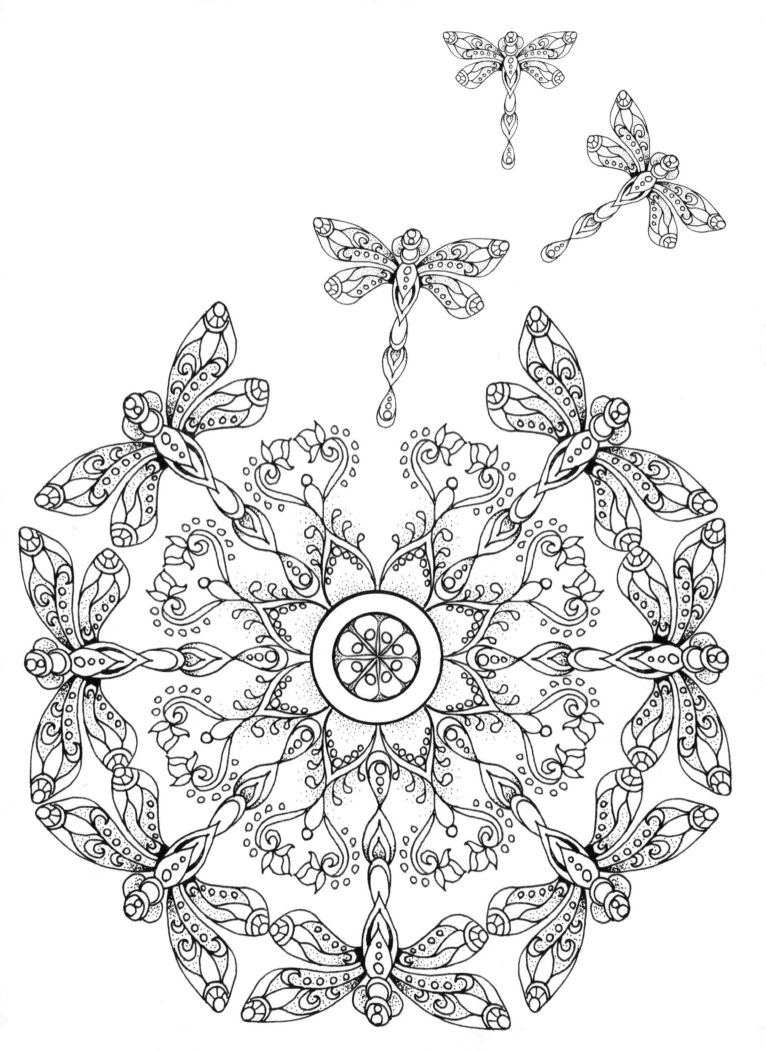

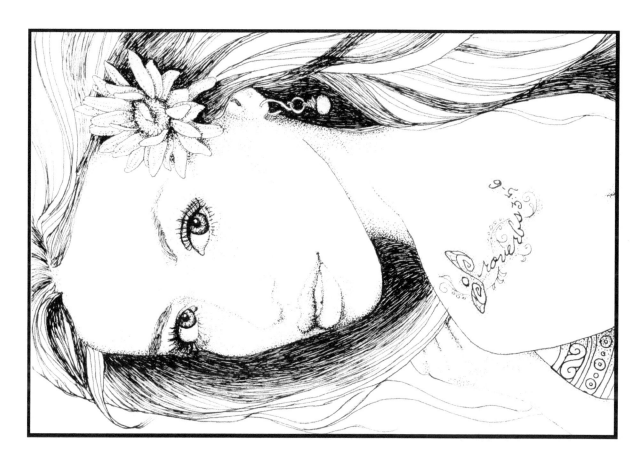

4x6 for photo frame or greeting card

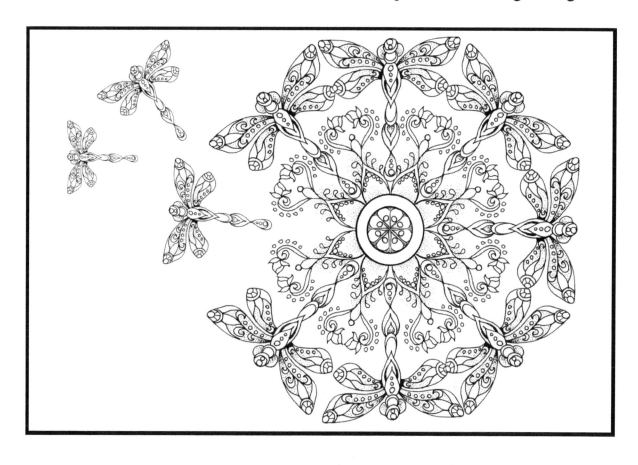

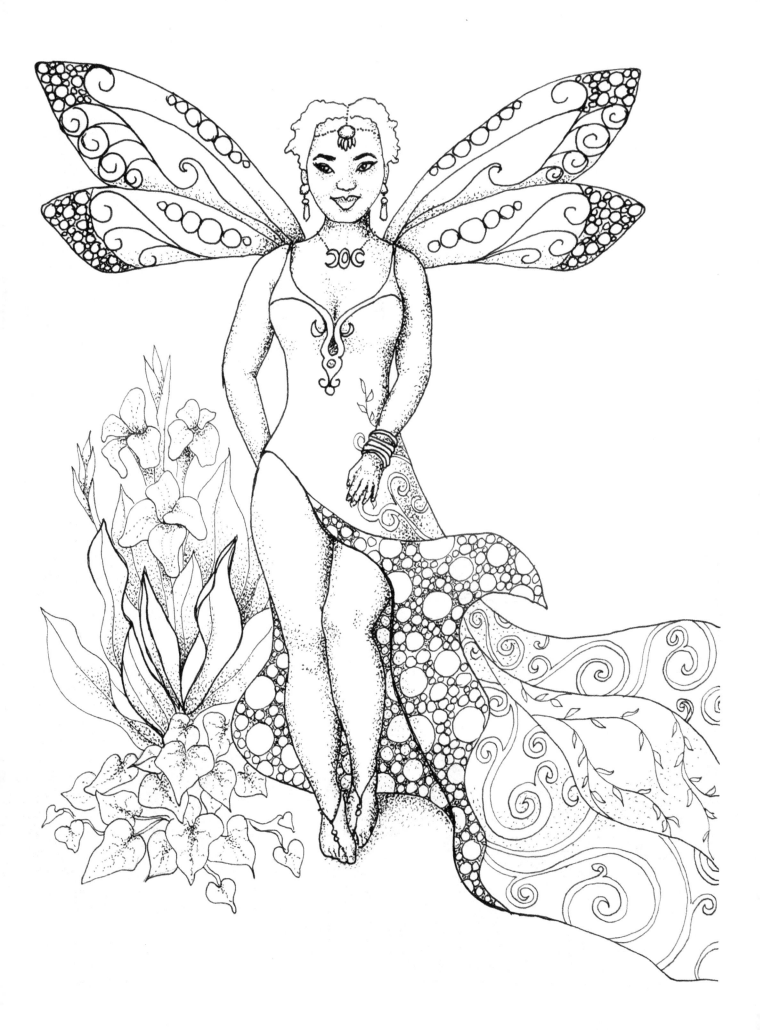

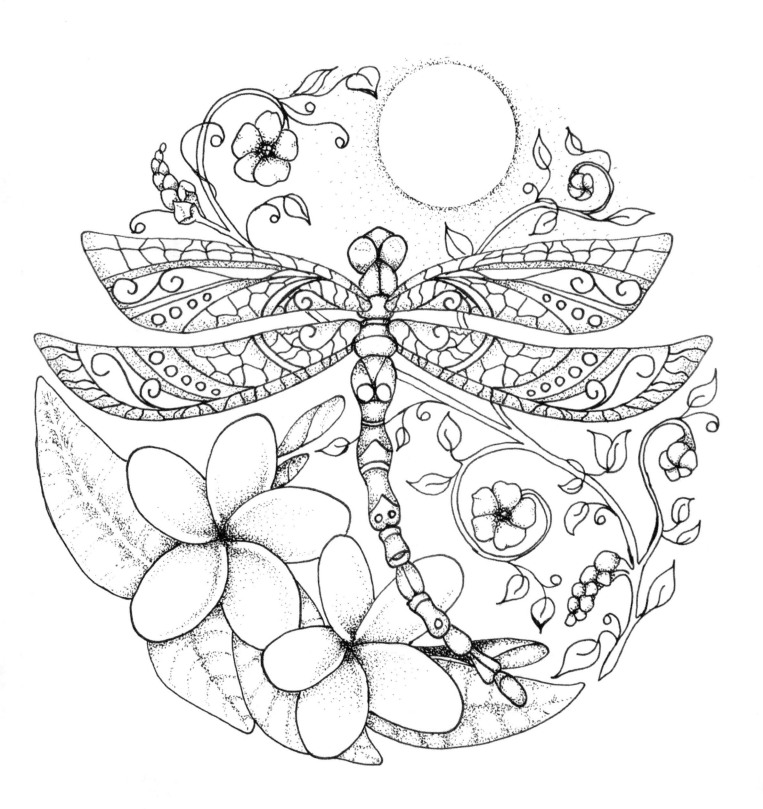

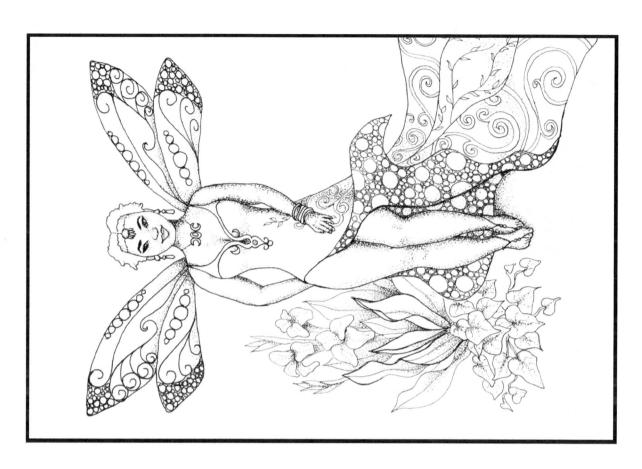

4x6 for photo frame or greeting card

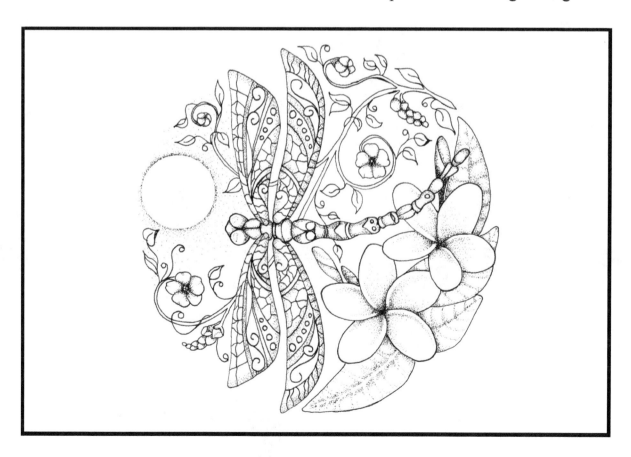

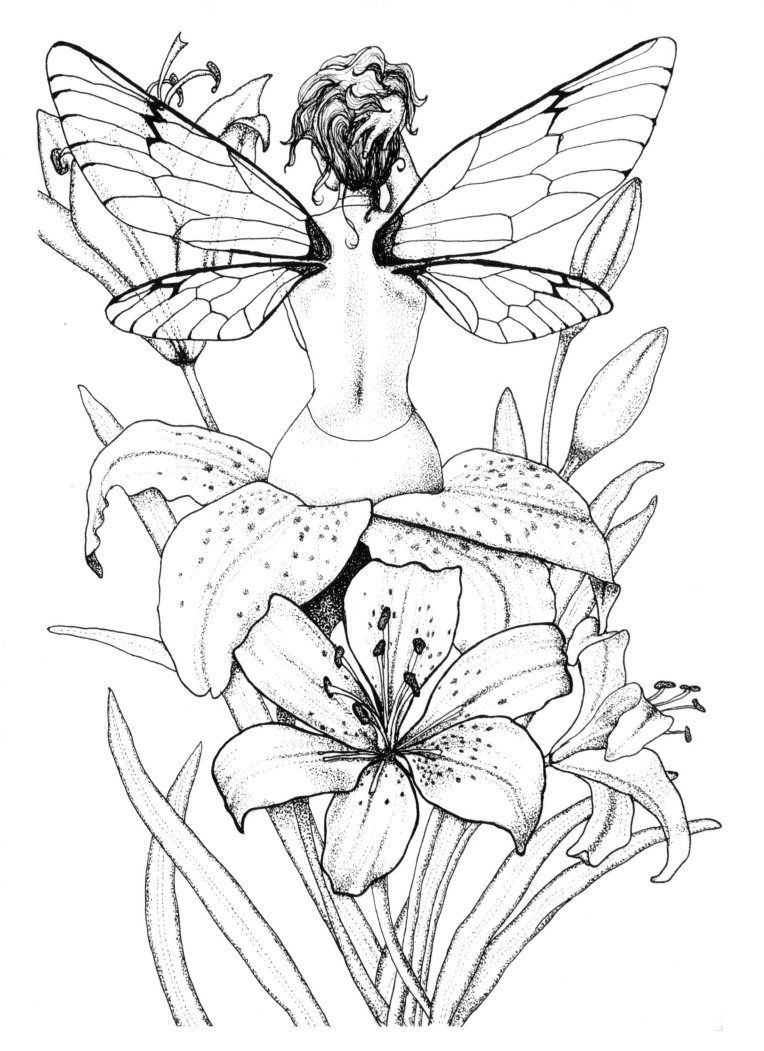

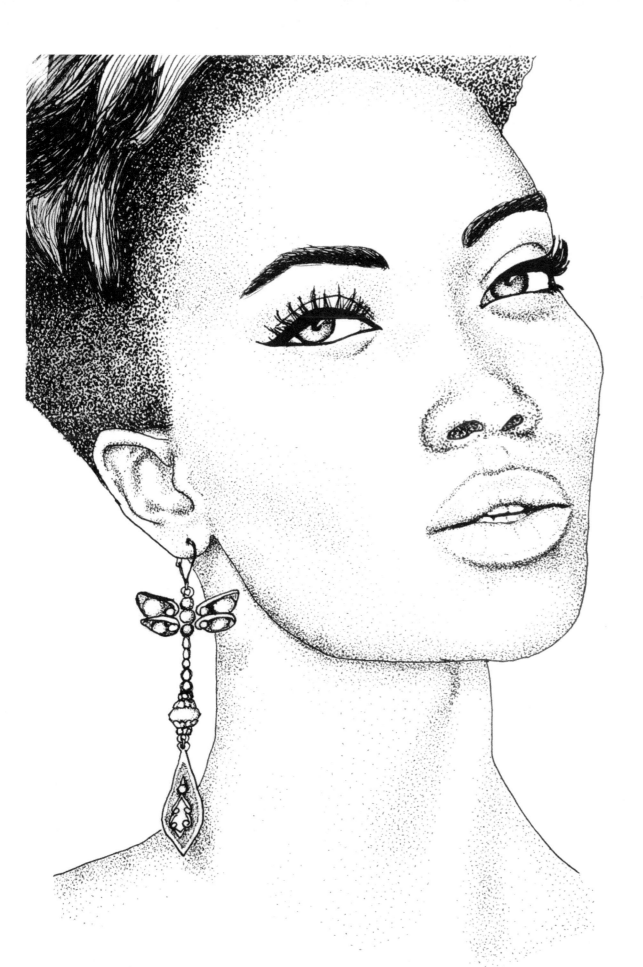

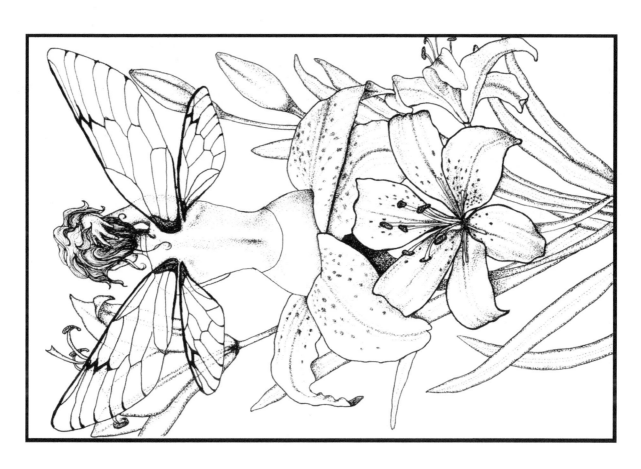

4x6 for photo frame or greeting card

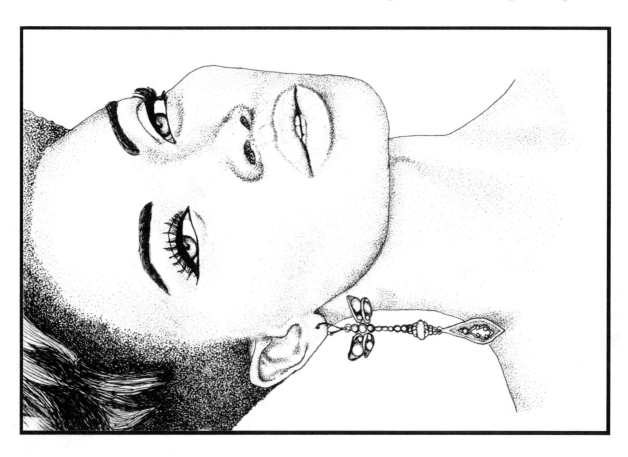

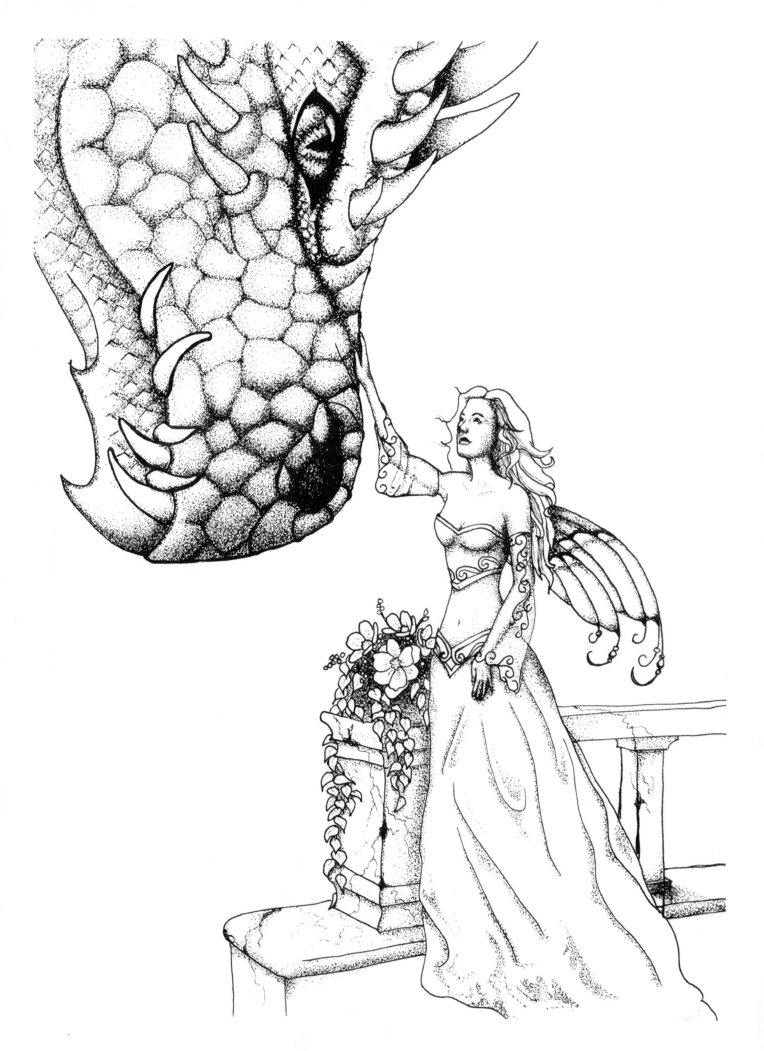

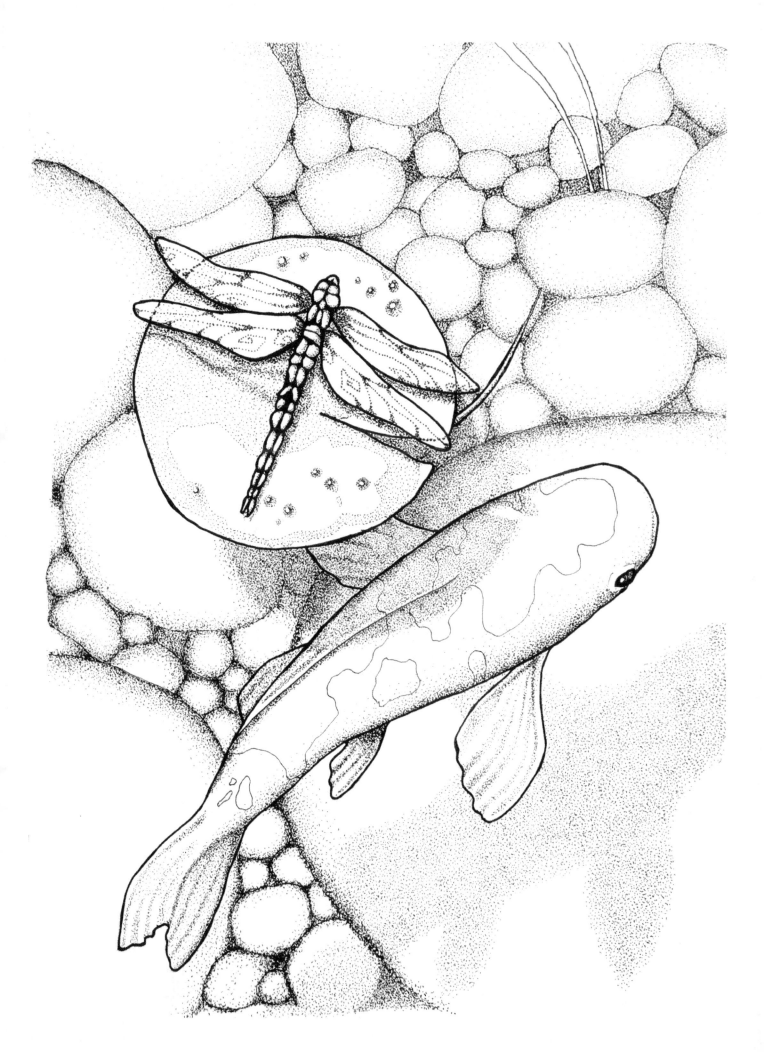

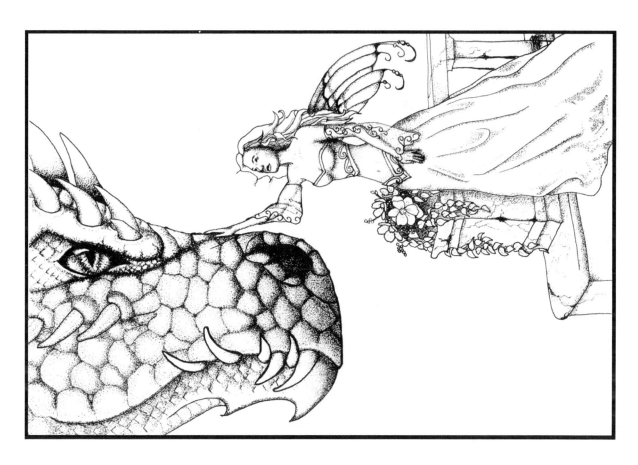

4x6 for photo frame or greeting card

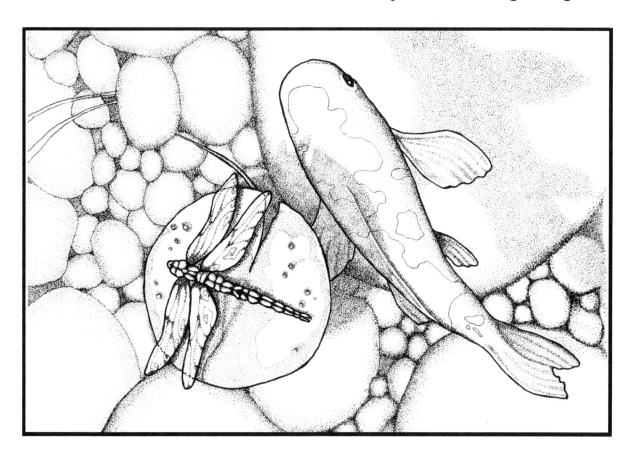

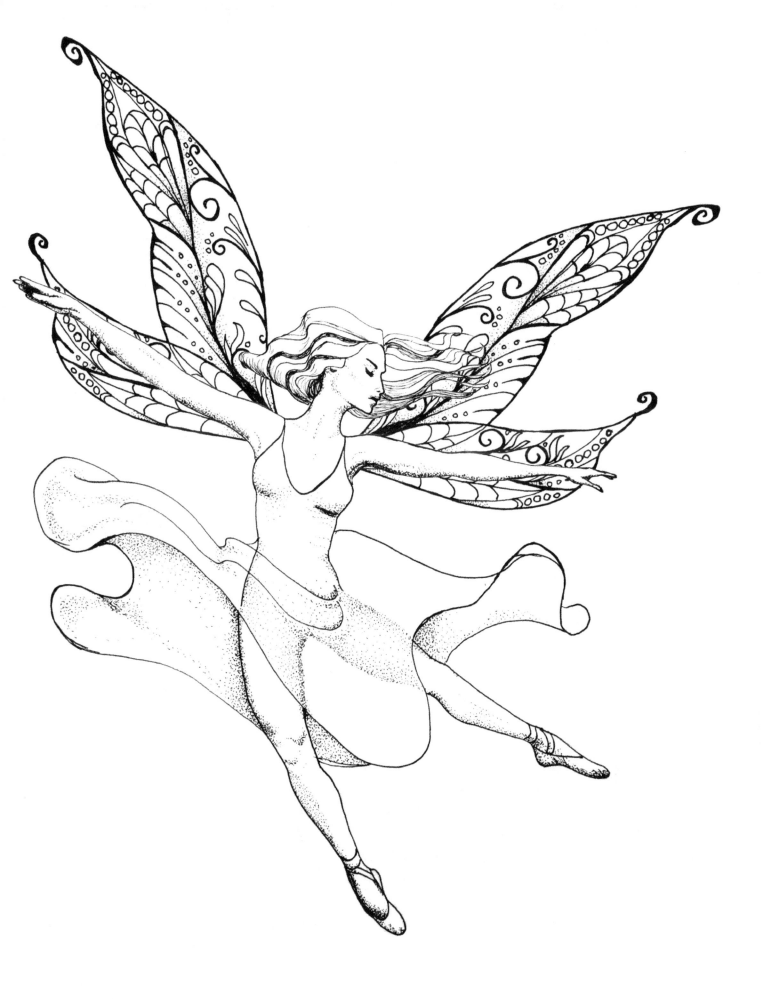

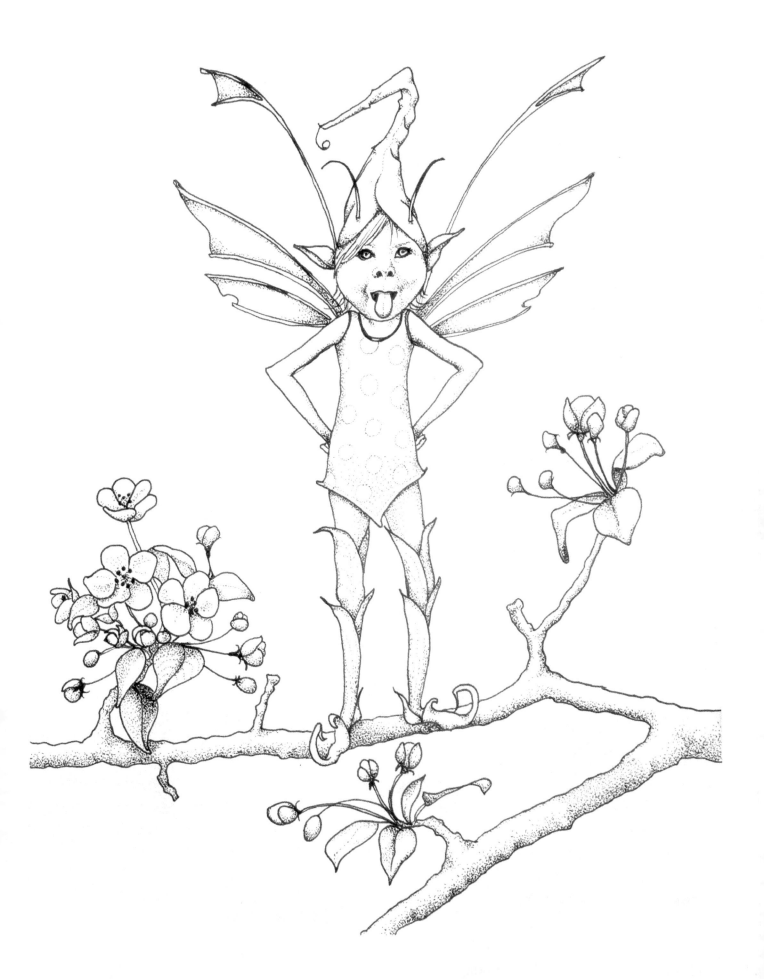

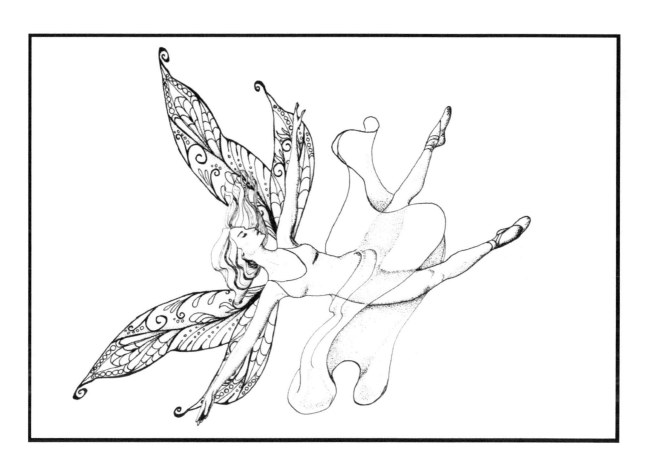

4x6 for photo frame or greeting card

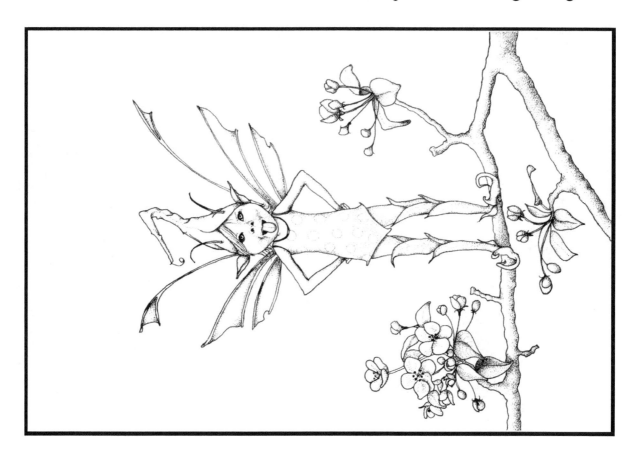

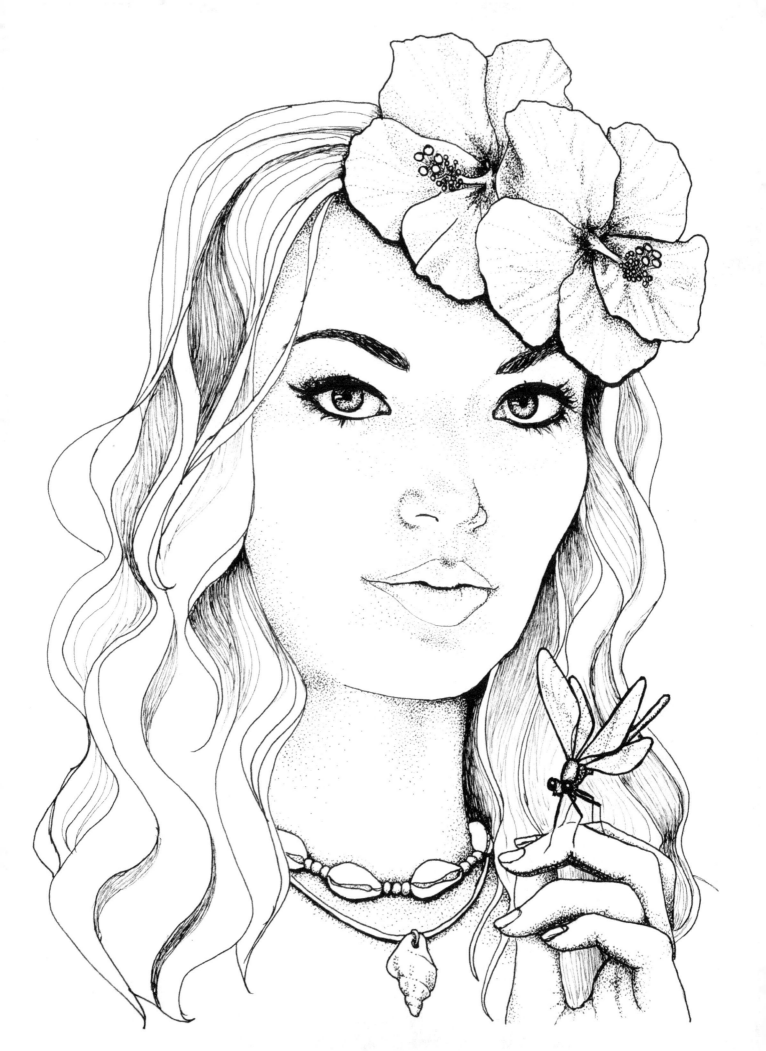

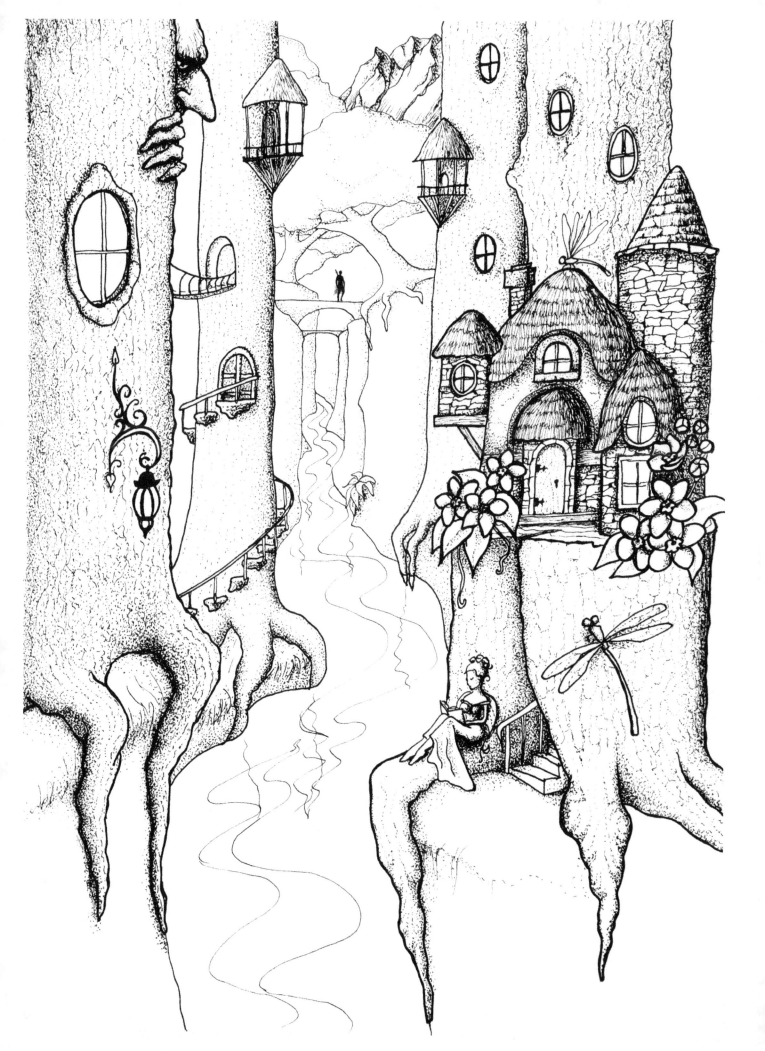

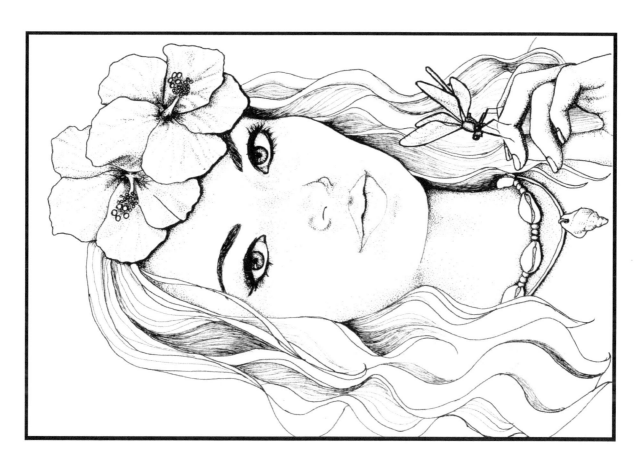

4x6 for photo frame or greeting card

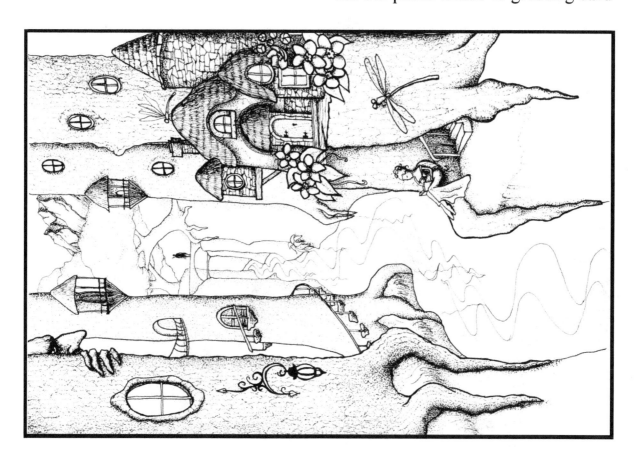